Copyright 2012 by Paul Counelis
ISBN: 978-1-304-18157-2
Hallow Harvest Books / Flint, MI

MIDNIGHT POPCORN:
FILM REVIEWS AND MOVIE ESSAYS

PAUL COUNELIS

CONTENTS

1) Zombieland 5

2) Halloween II 10

3) Top Five Horror Films of the Eighties 17

4) The Wolfman 21

5) Alice in Wonderland 26

6) A Nightmare on Elm Street 32

7) Ten Best Horror Films of 2010 38

8) The Black Swan 44

9) Moonrise Kingdom 50

10) The Amazing Spider-Man 57

11) The Lords of Salem 66

Zombieland (2009)

While *Zombieland* sets out to achieve a different vibe and tone than many of its counterparts in the recent wave of zombie comedies, it has just as many laughs as previous films such as *Shaun of the Dead* while still managing to retain enough 'wink wink' moments to please the horror crowd. It's clearly a film on a higher level than many similarly marketed films.

Zombieland: The Good

For starters, Woody Harrelson is absolute gold in the movie. That's an overused phrase nowadays, but his performance as zombie killer 'Tallahassee' is funny, bright, and even a bit poignant. The other actors are good enough to ward off his supercharged scene theft for the most part, with each main character having an interesting take of his/her own. Jesse Eisenberg in particular shines as the shy, nerdy, but

endearing 'Columbus'. He does Michael Cera even better than Michael Cera, with more humanity and believability to his stuttering dorky affectations.

The direction is top notch. There is a continuous running gag regarding Columbus' list of rules (ways to avoid getting overtaken by zombies), and it's handled in a fresh, amusing way that has to be seen. The cinematography is nice, with plenty of great visuals and even some eye-popping scenery along the way.

Also notable is the soundtrack, which kicks right in with Metallica's "For Whom the Bell Tolls" and sets the tone for this excellent film. Many theater-goers may leave the film singing Van Halen's "Everybody Wants Some", a particularly inspired choice and much more fresh than the overused songs of the eighties metal catalogue.

The plot is pretty easy to follow: most of humanity has been overtaken by zombies, and America has been re-named Zombieland as a

result. A few remaining human beings struggle with what's left of their real lives, all the while avoiding and killing the zombies that show up along the way.

Zombieland: The Bad

There isn't much by way of criticism to offer here; if you like the genre, you will most likely be pleased with the film. If you don't have a previous affection for this type of movie, you may still find yourself smiling and being drawn in by the fun and interesting characters presented.

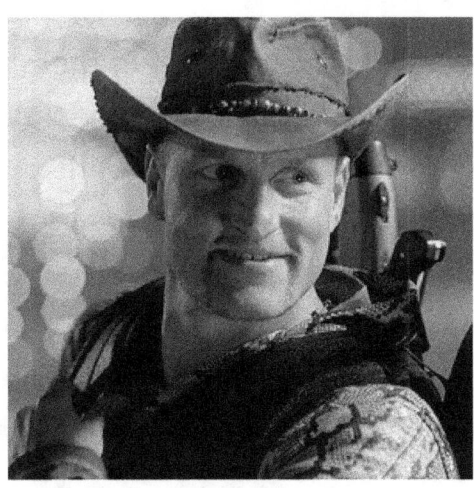

If there is a nitpick, it's that the flow of the film is kind of disrupted here and there, particularly by the scene that's become a

notorious spoiler on the internet because of its celebrity affiliation. It's a strange and funny scene, and a very unique one, but maybe goes on a bit long, as it seems to pull out of this bizarre cinematic world and become somewhat aware of itself. But it's a small complaint and shouldn't hinder enjoyment of the film overall.

There have been complaints of too many lulls in the movie, but some of those perceived 'overdrawn' scenes are among the most interesting and really help to drive the emotional impact home.

Zombieland: The Ugly

The zombies! The special effects (many of them practical - yay!) are more than solid, and the filmmakers don't skimp on the gory details (if you like that sort of thing). It's as if they wanted to achieve the feeling of a more notorious zombie flick, like a Romero "...of the Dead" offering, so as to make the comedic bits stand out even more in contrast.

Director Ruben Fleischer has mapped out a pretty fun and appealing film. It's hilarious, has a couple of decent jump scares, and as stated, even has a touching moment or two (somehow). *Zombieland* is a good example of the 'zombedy' sub-genre, and may even become a classic.

Halloween II (2009)

When Rob Zombie 're-imagined' John Carpenter's film "Halloween", many people were taken by surprise. The theatrical cut of that film was fascinating, well made, loaded with amazing imagery, and, at times, flat out baffling. One thing was clear: Zombie had a knack for making a film all his own, despite the affiliation with the Carpenter film and the obvious character takes.

The first film was brutal, intriguing, and at times even moving. The character of young Michael Myers was ably played by Daeg Faerch, bringing an empathy to the character that never really existed before. And as such, viewers were torn even as they watched the film. It was a confusing position to be in, relating to a character who is essentially evil, yet having been through Michael's childhood with him and seen through his eyes, the eyes of someone

clearly misunderstood and under the thumb of an abusive authority figure.

In the first half of that film, Zombie painstakingly created a dark, stunning portrait of a young psychopath. Young Michael wore the mask of sanity before he grew into the mask of a psychotic stalker. Care was taken to develop the relationship between Myers and his mother (Sheri Moon Zombie), and even Myers and his intense doctor, the iconic Loomis, portrayed with convincing verve by Malcolm McDowell.

The adoptive family of Myers' baby sister Laurie Strode was explored just enough to also make the viewer empathize with the likable young Laurie, so much so that when the two met near the climax of the film, the emotional stake in each character was plausible enough to create a strange juxtaposition in the viewers' minds. Yes, we want Laurie to escape and be safe...but is there anything left of the young Michael inside of that monster with the mask, the pre-teen boy

who looked out for little 'Boo' Laurie when she was only months old?

The film didn't connect with the entire horror community, but there was enough there to suggest that Zombie's next film could be a revelation.

Halloween II: A Sequel Unhinged

With the aptly titled Halloween II, Zombie eschews such disarming and in depth exploration of the characters' psyches in favor of disjointed dream sequences, over the top brutality, and a much more predictable overall direction.

One year later, and Laurie is now a disturbed teen, living with Annie (who, in an unpredictable move, made it out of the first film) and Annie's father, Sheriff Brackett (Brad Dourif in an extremely good turn). Laurie is torn between the nightmares of Michael's return and her desire to return to her everyday life. Meanwhile, Michael has escaped from custody

(was he ever really dead?) and has been traveling since, apparently on a hopeful collision course with Laurie in an attempt at a family reunion of sorts.

Throughout Michael's journey, he inexplicably stalks from town to town mask-less. He stops to kill on multiple occasions, donning the mask before taking on his serial personality. Why he somehow now doesn't wear the mask at all times is never really explained, other than the notion that the actor Tyler Mane wanted to show off his sweet new beard (which, admittedly, is pretty awesome).

Throughout the film, the new adventures of Loomis are also visited. The doc is now hellbent on making money off of his status as Michael's onetime confidant. This persona finds him being humiliated on talk shows, and in maybe the single most interesting scene of the film, being confronted by the father of a Myers victim.

The rest of the film is a bizarre display of Myers' visions (his mother with a white horse walking alongside a young version of himself) and Michael basically destroying everyone in his path to Laurie.

The brutality of the film reaches astonishing caricature heights. In his efforts to make the film more realistic, Myers becomes almost a parody of himself. Every confrontation seems to end with Michael endlessly stabbing (and grunting loudly, Hulk-like) until the scenes aren't really horrific, but revolving between burlesque and tedious. Perhaps that was Zombie's intention, turning the table on the audience in an effort to portray the bloodlust of the film-going crowd and their eventual desensitized boredom. As such, it still doesn't work, because the film is never touched with the realism of the first and therefore doesn't retain the impact of that film's more violent scenes.

The characters are never really fleshed out, and Zombie seems to rely on the viewer recollection of the emotional impact of the first film for his punch throughout. It doesn't really work. The story doesn't feel like a true continuation of the first film, largely because the mood and pacing of the sequel are so different. The least interesting character in the film is Michael himself, a huge change from the first film.

That's not to say that there aren't some good things in *Halloween II*. Much of the imagery is rich and beautiful, in particular a grotesque sequence featuring pumpkin-headed people eating in a cloudy, dream-like surrounding. The shots featuring Michael's mother (however unnecessary some of them have been deemed to be) are lovely and extremely well filmed.

Brad Dourif, as mentioned, plays the stand out role as the sole likable character, Sheriff Brackett. He plays the role with a sweet subtle realism. His reactions and situations are believable, and he's outstanding throughout.

The rest of the actors vary in competence, though most are adequate for the requirements of the film.

Halloween II: Ambitious but Unsatisfying

Zombie's Halloween sequel is strange, intriguing, and ultimately unsatisfying, though his ambition has clearly not been stilted. His direction is even handed and warrants further filmmaking opportunities. His vision is still clearly not the vision of a more mainstream director, which is probably a good thing. If his apparent nihilism has been exorcised through his first four live action films, he could probably benefit from exploring a different aspect of the human condition.

Top Five Horror Films of the Eighties

Most lists focusing on the best horror films of an entire decade are going to be different than the next. There will be various reasons for why one movie makes one list, but not another. This list attempts to corral the top five horror films of the eighties based on this sequence of criteria.

- Popularity
- Influence
- Creative impact
- Eighties representation

Some movies would score high in one category, but not as well in the others. A few of those films on the "just missed" list are Stan Winston's wonderful *Pumpkinhead*, Clive Barker's creepy *Hellraiser*, Tobe Hooper's *Poltergeist, Fright*

Night, The Lost Boys, and Fred Dekker's awesome (and soon to be released to DVD) *Night of the Creeps.* There are cult favorites not included on the list, not because they're not good films, but because there is only room for five. Number six would probably be *An American Werewolf in London*, for instance.

So, without further ado...

5) *Return of the Living Dead* - Director Dan O'Bannon's cult magnum opus, about zombies who overrun a town. This movie kind of defines the decade in terms of splatter, effects, and the combination of horror and comedy so prevalent at that time. Embodies the "feel" of an eighties film.

4) *The Shining* - OK, so Stephen King wasn't madly in love with Stanley Kubrick's vision of King's book. Still, it stands the test of time, with Uncle Jack Nicholson's eerie turn, strange and unique visuals, and a style that would be copied

relentlessly to much less success over the next twenty years. Recently released to Blu-ray.

3) *The Evil Dead* - Sam Raimi's low budget splatter-piece that introduced genre fans to fanboy hero Bruce Campbell. Campbell, as Ash, is lasciviously abused onscreen by undead creatures, some of whom used to be his friends. Strange, unique, and extremely influential film.

2) *A Nightmare On Elm Street* - Wes Craven's most iconic creation, and one of horrordom's most beloved characters, Freddy Krueger makes his debut in this dark, scary flick. Robert Englund snarls and slinks his way to a fan favorite performance, and the phenomena of Freddy is born. Creepy and effective to this day.

1) *John Carpenter's The Thing* - The master's best film of the eighties also doubles as one of the decades most popular, often cited as the best horror film of all time. Rob Bottin's mind blowing effects and the nightmarish setting make this one of the most memorable horror

movies ever made. The "Norris Creature" is one of the most popular monsters of the decade, despite the limited screen time. Originally bombed at the box office amidst height of the feelgood gigantic hit *E.T.*, but found renewed life on Home Video. If you haven't seen this film...well, what are you waiting for?

The Wolfman (2010)

"Even a man who is pure in heart and says his prayers by night, may become a wolf when the wolfbane blooms and the autumn moon is bright."

Just as with its classic predecessor, 1941's Universal production of *The Wolf Man*, director Joe Johnston's re-imagining is steeped in gothic folklore. Both films owe the legends and myths of the lycanthropic monster to legendary screenwriter Curt Siodmak. Siodmak originated virtually all of the modern mythology of the cinematic werewolf, from the full moon to silver bullets to the enduring gypsy phrase quoted above.

Revamping a Universal Monster

The Wolfman is a modern retelling with acknowledgment to the original. While it features plenty of dark imagery and wonderful makeup (courtesy of the great Rick Baker, "The

Monster Maker"), it is also much more gory than the 1941 film and it's mixture of practical efx and CGI could be considered a curse as well as a blessing.

Lawrence Talbot (Benicio del Toro) returns to the family home for the first time in years, to help deal with an attack on his brother by what appears to have been some sort of animal. He's welcomed by his father (Anthony Hopkins, in a wonderfully appealing and sufficiently hammy performance) and his brother's fiancee (Emily Blunt). Soon after, he confronts the creature who killed his brother, and the results are disastrous for Lawrence.

The Good Stuff About The Wolfman

The film features some stunning cinematography by Shelly Johnson. The rich, dark tones of the film are as much stars of the film as del Toro and company. The editing, led by legendary editor Walter Murch, is nothing short of brilliant. The scenes with the Wolf Man

running wild through the Moors are lively and tight.

The acting is mostly good. People who have been parroting the critical claim that del Toro phones his role in are largely mistaken. He's decent and affecting as Lawrence Talbot (though nowhere near as sympathetic or likable as his 1941 counterpart Lon Chaney Jr.). Hugo Weaving is very good as Abberline, the inspector. Rick Baker's practical makeup is very good. Del Toro's wolf makeup puts one in the

mind of the great Jack Pierce's wonderful iconic Wolf Man. There are other nods to the Universal classics, all welcome and well done, for the most part.

Great score by Danny Elfman, as well. Lively and relevant.

The Bad Stuff About The Wolfman

While much of the story moves along at a nice speed, there are some slow moments that perhaps linger a little. This is a very small quibble with the film. Some of the CGI is much too noticeable, particularly a couple of cartoonish transformation scenes

The Wolfman appears to be inconsistent in speed, at times moving much too quickly to get the feeling that the creature has any sort of real mass. There are also a couple of inconsistencies within the story itself.

None of this ruins the film. It stays pretty much exciting and watchable throughout. Overall, it's

a gothic, kinda silly, fun retelling of a classic story. The 1941 film is in no danger of being replaced in the annals of history, but you could do a lot worse with your eight bucks than to sit in a dark theater and watch this saga of the children of the night unfold.

Alice in Wonderland (2010)

"You've lost your muchness," says The Mad Hatter, Johnny Depp's latest whirlwind characterization of a pre-existing character. Depp makes himself the Hatter in such a way that it would almost seem odd if someone else had tried to portray the role. And if Alice has lost her "muchness" as the Hatter implies, Tim Burton's loss of muchness has been greatly exaggerated. If anything, with "Alice in Wonderland", he's found at least some of it again,

Sinister Undertones of the Mad Hatter

Burton has never been one to play into the common aspects of the mainstream film. He's one of film's all time most innovative visual directors; if the term "visionary" can be applied to a filmmaker, he defines that appropriation.

His characters are routinely exaggerated, and even the brightest have a dark underside, and that's just the way he likes it. Alice is no different. Perhaps the most surprising aspect of his Alice adaptation is the sinister aspect of the Hatter character, made all the more bizarre and effective by the master thespian portraying him.

As the Hatter, Depp is much more than the trailer implies. Yes, he IS a silly, goofy looking huckster who delivers the silliest lines with a delicious glee...but he's also capable of implying an underlying pathos. And even more welcome in a performance in which not much character development is warranted (or needed, for that matter) is that dark, deep rooted, true disturbance of behaviour. It's those moments that define Burton's film, and suggest that further exploration of the Hatter might be a thrilling event. The implication of the Hatter's schizophrenia isn't as surprising as the effectiveness of the moments when the sinister side of the Hatter surfaces. He becomes

unpredictable, and thus elevates the proceedings to the same level.

Some will say this is just another of Depp's kooky characterizations, but they're missing something with that easy shortcut: the deft (and daft) brilliance of Johnny Depp in relation to the overall feel of the film. He's one of our bravest actors in this way, because he takes chances that other actors wouldn't fully commit to...even if they wanted to. Sometimes he makes bad decisions, but he never seems to mail them in. There might be the temptation to write off his performance as less because of the nature of the character. After all, this isn't DeNiro in *Taxi Driver*, right? But to ignore a great performance because of it's oddity is a mistake.

How Good Is Alice?

And what of the movie itself? It would seem that doing something unique with a story that's been retold and reiterated dozens of times

since its inception 150 years ago would be quite a task, one that filmgoers might overlook. It's quite an ambition to try something new with a story like this, but of course that's what attracts Tim Burton to projects such as these. He succeeds in immersing us in a world of his creation, at least as immersive as the lush landscape world of the multi-nominated *Avatar*. The bottom line is that the movie isn't as good as Burton's very best, but not as bad as his worst. And that still makes it pretty darn good.

The acting is good, and for the most part, fitting. The amazing Helena Bonham Carter threatens to steal the show yet again (as with *Sweeney Todd*) as the regrettably large headed, motor mouthed Red Queen. She is amusing and delivers her lines with zest and zeal. Mia Wasikowska plays Alice as she should be; going along for the ride, content to let the Hatter and the Red Queen as well as any number of CGI characters bask in the absurdity of it all. She's effectively expressive and lovely in that fragile

way...but still manages to look cool in the Alice "armor". Crispin Glover is good as the Knave, if a bit underused. The exception is Anne Hathaway, who seems to be trying to channel Glenda the Good Witch, but with irritating and distracting results.

The voice characterizations are all very well done, standouts being Alan Rickman as the Blue Caterpillar and the iconic horror star Christopher Lee, who makes his few lines as the Jabberwocky extremely memorable.

Visually, the movie alternates between multi-colored dreamscapes, nightmarishly garish dark hues, and strange close-ups framed with barren sky...reflecting the ever-changing overall mood of Underland as apparently dictated by it's dwellers.

Tim Burton's Wonderland

Alice in Wonderland illustrates the genius of Tim Burton, and also his perceived flaws. While not as ultimately satisfying as some of his self-

penned masterpiece works of fantasy and fairytales such as *Edward Scissorhands*, the film is still worthwhile and kids should especially love visiting the wondrous and lush world he's designed. It's better than some of his most recent forays, such as *Charlie and the Chocolate Factory*. Much more...muchier.

A Nightmare on Elm Street (2010)

Platinum Dunes, production company of blockbuster moneymaker Michael Bay, has already remade several of the most beloved of the contemporary horror films with a decent re-imagining of Leatherface and the Texas Chainsaw Massacre film, along with a couple of fairly unsuccessful attempts at remaking *The Amityville Horror* and *Friday the 13th*.

Now, Platinum Dunes steps in with a new take on a beloved horror franchise, maybe the most beloved of the modern era; Freddy Krueger and *A Nightmare On Elm Street*. Directed by music video veteran Samuel Bayer, the film stars Jackie Earle Haley (*Watchmen*) in the iconic role that Robert Englund played to perfection in the original and it's seven sequels. Series creator

Wes Craven has no involvement and is listed only as the creator of the characters in the new film's credits.

The NEW new Nightmare

So, is this new take on the Krueger myth any good? In a word, no...but there are a few things to suggest that Bayer should be given another chance in the genre, beginning with the wonderful look of the film. It's gorgeously rendered, with extremely detailed sets and a dark, airy atmosphere that *could* have culminated in a good film, if the script were not so poor and ill-conceived.

But the biggest question that most people with interest in the film want answered is "How is Jackie Earle Haley in the role of Freddy?" The answer there also lies in the script, as Haley, a fine actor, does what he can with the limitations of the dialog and the speech impediments created by the unfortunate makeup. He looks like a cross between an animatronic puppet, Dr.

Phibes, and some sort of creature that may have emanated from the original series and eventually modified itself into Englund's Krueger. In short, it's largely ineffective and actually detracts from what Haley may have been able to contribute. Instead, we're left with stilted speech patterns and very little by way of facial expression, and not much there to actually scare film-goers.

In the original series, there are obviously some abysmal entries, but the entertainment factor is pretty much always present due to the gleefully creepy presence of Robert Englund as Freddy. No matter how bad the films got, how terrible the dialog, there was always something to watch in Englund's lasciviously inspired performance. in comparison, the new film has neutered Haley by not really giving him any kind of compelling story or lines, and it's actually made worse by the fact that you've pretty much seen everything done in the film already, except that it was mostly all done better before. Even

the effects, which seem artificial by today's CGI standards. None of it feels very real, so there isn't much by way of involving the viewer emotionally, because there's never a sense that anything of any real weight is actually occurring on the screen. When a person is attacked by Freddy, the first thought shouldn't be to point out the obvious CGI of the scene. Even the most quaint practical effects of the first Freddy films are more effective than the artificial scares generated by the new movie.

Dream a Little Dream: Was Robert Englund Busy?

The acting in the film, aside from Haley and a couple of others, isn't very effective for the most part. The Springwood teens are pretty, posey, interchangeable, and mostly uninteresting. Kyle Gallner provides a couple of interesting moments as a tortured soul (he even wears his Joy Division shirt like a uniform), as does "the new Nancy", Rooney Mara (probably the most 'real' teen as far as characterization

goes, which honestly isn't saying much). Overall, the characters are all pretty forgettable; not a Nancy Thompson or Alice Johnson in the bunch.

The first Nightmare film was high concept, high scare content, and dark. It's impossible to stop comparing the new flick to the original, because it borrows so heavily from the first film. This is another of the movie's many problems; the remake brings literally nothing new to the table. No real twists, no surprises, even the dozens of jump scares fail to cause a reaction beyond the first few, because the audience comes to expect them. The original film kept Freddy in the shadows often, and the overall feeling was that he actually treasured the moment of fear in his victims. Even when spewing his one-liners with glee, the notion that he was pursuing the fear factor above all else is prevalent.

In the new film, the one-liners are still present. In fact, they come with more regularity than one might expect given the extremely dark subject matter and the filmmakers' apparent

goal of creating a meaner, more focused Freddy. But by the end of the film, even the most casual fan of the original films will probably just wonder what Robert Englund would sound like delivering the same lines.

The Ten Best Horror Films of 2010

With each year, hundreds of horror films are released. From theatrical to straight to DVD releases, even made for cable movies; the horror genre is as strong as ever. The debate over which ones are the best is endless and the source of many a great debate amongst the horror faithful. In that spirit, here is a list of the ten best horror films of 2010, a much maligned year for many horror critics and fans...

10) Splice

"Splice" is an imperfect film. Let's be clear about that right away. It has a somewhat weak climax and a meandering middle. But it's daring, engrossing, and highly effective...and VERY, VERY WEIRD. Body horror is a sub-genre that isn't always as compelling as it is here.

9) The Wolfman

OK, this one is EXTREMELY flawed. But underneath the shiny CGI, flimsy story and the perceived "mail in" performance of Benicio del Toro's version of Lawrence Talbot is some gorgeous, dark gothic scenery and some excellent special FX. Universal's doomed lupine framed howling in front of the evening moon is worth the price of admission, or at least a buck rental from your local Redbox. And Anthony Hopkins chewing scenery is a bonus, depending on your perspective.

8) Devil

M. Night Shyamalan penned this Hitchcockian tale of claustrophobia, good and evil, and the result was a surprising mix of tension, scares and even a small twist. One of the biggest surprises? It didn't suck. Some perceived it as a little preachy, but it has power and some great imagery.

7) Daybreakers

It's hard to talk about this futuristic vampire film without mentioning the shiny, brooding bloodsuckers of "Twilight". This film showed that the vampire genre still had teeth beyond the soapy phenomenon. "Daybreakers" paints a much less romantic and much more apocalyptic scenario; vampires are the majority, and the humans that are left have to be aware of the undead presence at all costs. Plus, Willem Dafoe's over-the-top vampire hunter, Elvis. Yay!

6) Suck

This direct-to-video black comedy has all the makings of a cult classic: funny situations, dark subject matter, one of the most intriguing vampires in recent memory, and Alice Cooper. A band finds that they can be more appealing to the masses if their music is immortal. A quirky, odd amalgam of comedic horror.

5) Black Swan

Far from the orthodox, standard horror fare, Darren Aronofsky's dark vision just might earn

its star Natalie Portman an Oscar nomination for her intense portrayal of a ballet dancer under extreme duress. Alternately lovely, horrific and with elements of camp, it is memorable and haunting. The best overall film on the list, fairly easily. Being as it's not going to be universally recognized as flat out horror, its number five here.

4) The Walking Dead (TV series)

Let's be honest here; the six episodes of "The Walking Dead" are probably the most impressive media offering of the horror genre in 2010. It's at fourth on this list only because of its non-theatrical status. Robert Kirkman's zombie comic book come to life proved to be everything horror fans hoped it might be, and then some. A horrific, absorbing and surprisingly moving tale that left viewers anticipating the upcoming second season.

3) Shutter Island

Sure, the twist is predictable, but Marty Scorsese's engrossing tale is loaded with creepy imagery. Stylish and compelling horror noir with some wonderful cinematography and gorgeous visuals, "Shutter Island" showed off Scorsese's horror chops and had many clamoring for more genre offerings from the legendary director.

2) The Crazies

What the---? A great remake?! This retelling of Romero is tense, exciting and surprisingly very, very good. Edge of your seat situations and creepy apocalyptic setting combine for one of the best horror films of the year. This is the way it should be done. Fast paced and exhilarating.

1) The Last Exorcism

Divisive reality horror has supporters and staunch detractors, but this genre bender was nothing if not memorable. Creepy atmosphere and some pretty darn good acting lead the way into a surprising and disturbing shift toward the climax of the movie and hurtles viewers

headlong into one of the strangest, most abrupt endings in recent memory. Love it or hate it, "The Last Exorcism" proved that the best horror is nothing if not unpredictable.

Honorable mentions: "Let Me In": worthy American remake with some iffy CGI, "Frozen", "Buried", "Splice", "Lake Mungo".

The Black Swan (2010)

The Black Swan begins with an arduous and unusual dream; swooping in and out of reality, a foreboding of what is to come in this magnificent and darkly campy melodramatic horror. Natalie Portman's Nina Sayers moves from dream to reality in the scope of seconds, and leaves the audience to answer the same questions that Nina herself must answer along the way.

This is an unusual and unique picture; a film swelling with passion, movement and grace, and simultaneously visited by terrifying visuals and challenging themes. Nothing here is really as it seems, and even multiple viewings bring fascination and intrigue. This is a memorable movie, made with a masterful touch by a somewhat underrated director (Darren Aronofsky) who has become synonymous with getting the best out of his talented actors.

The White Swan

In Aronofsky's harrowing film *Requiem for a Dream,* Ellen Burstyn delivered one of the most startlingly great performances in the history of cinema. She was nominated for Best Actress by the Academy of Motion Picture Arts and Sciences, but somehow lost to Julia Roberts, who won the Oscar for *Erin Brockovich.*

For Aronofsky's gritty and fascinating *The Wrestler* (2009), Mickey Rourke was nominated for the Best Actor Oscar and also lost, despite winning the Golden Globe.

Natalie Portman's performance in *The Black Swan* is nothing short of herculean, in terms of both physical and mental preparation and execution. She has already picked up some acting hardware, winning the Golden Globe for Best Actress, and seems certain to be at least nominated by the Academy.

Portman is absolutely stunning in the film, handling every swing of momentum, every

moment of her time onscreen with a dynamic realism. This never seems like an actress playing a role. This IS a tortured ballerina, driven to extremes by her mother, her obsession with her director's approval, and ultimately, consumption of her own drive for perfection in her chosen art form.

Her eyes achieve every expression imaginable in the span of the picture, from sadness, to seduction, to joy, to anger, to full blown bravura. She manages to convey more in a delicate sigh or a heartfelt shudder than many can hope for throughout the entire course of a film.

Her transformation is a slow burning but inevitable one, dancing along with a hypnotic pace, made daring and even thrillingly campy by the bizarre visions and creepy imagery that will likely haunt many viewers for some time afterward.

The Dark Soul

What also helps to elevate *The Black Swan* is the music. Tchaikovsky's breathtaking and brilliant "Swan Lake" is almost overwhelmingly present, and when the score drifts to original pieces, "Swan Lake" is always at the very least an echo or reprise. The music makes the strangeness of the film even more stirring, building as it does with the shocking, jaw dropping moments which might fall directly into B movie territory without it.

Aronofsky seems intent on revealing as much to us as Nina is privy to, which only serves to build the tension. By the time the film reaches it's climax, with the timeless power and beauty of the music ringing out, the entire film has become a fever dream.

The other actors in the film are very good as well, with Mila Kunis in particular also reaching an apex of her career so far. She plays a dancer

whose very presence fills Nina with an intriguing mix of admiration and fear, culminating in jealousy at the prospects of her dancing competence and worldly ease.

There are some extreme sexually charged moments that many will object to, though the case could be made for their inclusion on the basis of getting the film's characters and overall plot to the desired mental affect. That is, though these are scenes that could be considered exploitative, they aren't present merely for the act of exploitation. This is similar to the stark violence of Guillermo del Toro's masterpiece *Pan's Labyrinth*, in that the acts illustrate intangibles of the attempted

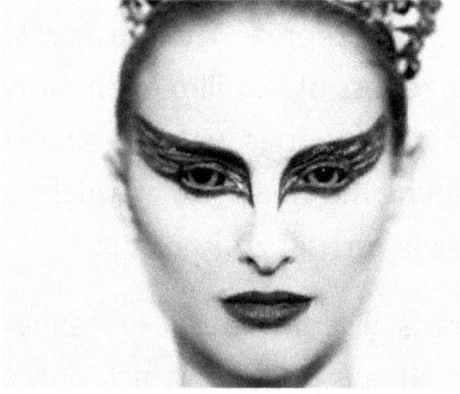

themes rather than showcasing only shocking set pieces.

Heart of Darkness

The Black Swan is not likely to appeal to everyone. It's a dark, sometimes absurd roller coaster of mystery and beauty, and will be challenging and maybe even unpalatable to many because of its melodramatic themes of obsession and artistic perfection. However, there will be few denying the impact of Portman's performance, and many are likely to complete their first viewing of the film feeling stunned, moved, and likely haunted for some time afterward.

And that is high praise for a piece of art, even one as simultaneously trashy, ambitious, lovely and ambiguous as this searing and soaring work.

High praise, indeed.

Moonrise Kingdom (2012)

Wes Anderson's seventh film *Moonrise Kingdom* begins with an almost hyper calm; the camera whirls around disorientingly, stopping to show us different, perfectly strange glimpses of what's happening in different rooms in the home of the people we are about to be eavesdropping on. It's a weirdly interesting and unique opening, compelling as much for its delightful cinematic style as subtle eye-raising content. As the film rolls along, with its wonderful, unique mixture of methodical, albeit brisk storytelling, it becomes apparent that the composition will threaten to overtake the cinematic oddities in a way that maybe no previous Wes Anderson film has accomplished. That is, there's a palpable grit of true emotion that rings throughout, giving his eccentricities more weight.

Moonrise Monarchy

The story of two children seeking refuge from their lives on a small New England island is told through current incidents and quick recaps. The boy, Sam Shakusky (Jared Gilman), is an orphan who has earned the ire of his fellow "Khaki Scouts" just by being a bit different than they are. (This is no small feat in an Anderson film, often largely populated with all sorts of unconventional folks). The girl, Suzy Bishop (played by Kara Hayward), has a penchant for creating havoc amid an already shaky relationship between her parents (a tragi-comical Bill Murray and uber expressive Frances McDormand). The two kids begin a "pen pal" relationship of sorts, which leads them to scheme to run away together to the woods.

One of the most profound moments of the film comes early on when Sam questions Suzy on her reasons for wanting to run away. She shows him the book that she found on top of the refrigerator, the title of which is "How to Deal

With a Troubled Child." Suzy's eyes instantly reflect her deep hurt Suzy. Sam's immature reaction - he laughs - turns her hurt to anger. It's also one of the few reminders that hey, this kid is only twelve. In a very big way, these tiny heartbreaks are the reasons the audience will relate and become attached to these characters. There are significant junctures where the camera is allowed to linger for maybe a second longer 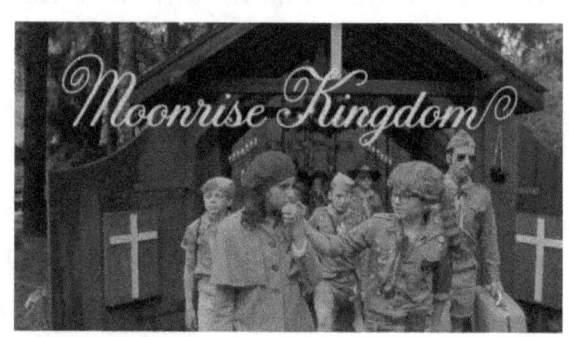 than it does in the more outright comedic segments. In fact, some scenes are structured with a kind of emotional schizophrenia; we might be driven to awkward laughter only a few seconds before one of those little shards of delicate despair strikes.

It makes the viewer aware that anything could happen, creating an unsteady consistency that drives the film with its paradoxical inevitability. That is, there is more than one reaction that the characters could have, and there is more than one road that the story could take. It's refreshingly pleasant poetry to watch, with the director confident that the understated complexity of present emotions is stronger than any direct imagery could be, regardless of how stark and striking.

His signature framed backdrops become the outline of a painting in which the characters' actions and reactions play out.

Wes Anderson's Magnum Opus

Wes Anderson's films often have a signature aesthetic, and they feature familiar actors delivering unfamiliar performances and *Moonrise Kingdom* is no exception: In *Moonrise*, Bill Murray plays his Walt Bishop in a nearly breakable way; it's different than the almost

stubborn acceptance of Herman Blume, his character in Anderson's excellent *Rushmore*. His voice is almost unrecognizable in a few scenes. In other words, he isn't just playing Bill Murray. Similarly, Edward Norton plays the perpetually confounded Khaki Troops leader Scout Master Ward with a touching innocence and concern.

Maybe even more impressive is the performance by Bruce Willis, far from his smart mouthed John McClain type roles. Willis is utterly believable and mostly sympathetic in his role as the local police captain. He's not delivering his lines in a tongue-in-cheek manner as his parts often call for, rather with a ponderous weight, as if he's really thinking about these things before he says them. He's not Bruce Willis scaling buildings and spouting catchphrases; he's a lonely, middle-aged man searching for hope in a small, idyllic town that he doesn't quite belong to and finding an unlikely friend he maybe didn't even know he needed. It's a charming, memorable portrayal.

The Bottom Line

Put simply, *Moonrise Kingdom* is a beautiful film. The art direction is exquisite, the colors are appealing and ambrosial without being distracting or obnoxious. Viewers are drawn into this singular dreamy world with delight; it's a very strong reflection of the importance of a child's individuality, as well as the many ways that adults fail them, both accidentally and out of exasperation. The kid actors are wonderful, portraying the freedom of a child's infinite imagination and the frustration with the adults around them, already resigned to their own unpleasant stations, and therefore trapping the children, however protectively and unknowingly. Their eyes are soulful, sad, playful, sometimes all in the same scene.

Driven by atmospheric music, the movie jettisons effortlessly between vivid images of sixties small town life, haunting climactic frames, emotional peaks and valleys, and little fragments of sheer delight. It's an example of a

contemporary artist with something to say, beyond the commercial triviality of another summer blockbuster.

Most importantly, it's a tiny peek into a different world, where charm and innocence are celebrated. And a desperate look at two awkwardly lovely children who seem fully and even painfully aware of their frail hold on what is likely the most unregimented summer they will ever experience.

The Amazing Spider-Man (2012)

Since the last film of Sam Raimi's *Spider-Man* trilogy was in theaters only five years ago, it would be pretty hard to watch Sony's new *Amazing Spider-Man* film without making at least a few mental comparisons along the way. However, if you expected the new Spidey movie to be little more than a re-hash of ground that Raimi already visited, you would be mistaken. There's plenty in the movie to recommend it as a stand-alone effort, none the least of which is Andrew Garfield's angst ridden, modern take on everyone's favorite everyman, Peter Parker.

Rebuilding the Legend

When plans to make another Spider-Man movie were announced, many wondered what the new filmmakers might be going to tackle; would they be dealing with the origin, only ten years

after Raimi and Tobey Maguire brought it to the big screen?

What Director Marc Webb and company did was to follow a familiar path (Spider-Man fanboys would expect nothing less, after all), but with a slightly more gritty and realistic look at Peter Parker's life. They took elements of the more recent comic book storylines of *Ultimate Spider-Man* and married them with the classic Spider-Man tale. This allowed them to bring the revered story into the present; Pete, while still a very dedicated science-y type, rides his skateboard to school and is maybe a bit less of a target for Flash Thompson, the school bully. Garfield paints the character of Peter with the very convincing combination of insecurity, guarded passion, awkward apprehension and a small, surprising sprinkle of confidence. He's a bookworm with a mysterious allure.

Garfield is very good in the part, all things considered. The inevitable comparison to Maguire is one hurdle for Garfield, but perhaps

the even bigger one is the expectation of the comic book community on one of the most beloved characters of all time. The gamble here is that the audience, or at least a large portion of the audience, will be able to embrace a slightly different interpretation...or even just accept it.

Rehashing the Legend?

So how about the story? Is it just a "do over" of the Raimi flicks?

In a word, no.

There are elements that reprise, but mostly in a varying style. The main plot points remain, of course; Webb would have been crucified had he attempted to restructure TOO much of the origin. But even if the story is similar, the difference is in both the character and the grounding of the world he exists in. This isn't a "comic book" city, full of color and spandex characters. It's New York, it's a real place, and

this kid Peter is just another awkward teenager that lives there.

That's what elevates the movie over quite a few other comic based films; this doesn't feel like an epic, "wink wink" event picture, where the characters make way for the explosions and the only exposition involves awesome looking vehicles. It plays out in a much more realistic fashion as a result. We see early on what eventually drives Peter in his way of thinking, whether it be his parents leaving in a mysterious fashion, the love and guidance of his Uncle Ben and Aunt May (very strongly portrayed by screen icons Martin Sheen and Sally Field), or his interest in science. We're plunged into the very real world of this kid, who we immediately empathize with.

Of particular interest are the school scenes and the moments that Peter shares with the lovely and thoughtful Gwen Stacy (Emma Stone). The emotional punch of the film relies on their relationship, largely. If you don't buy these two

as a couple, the impact of the entire story and the movie's climax will be lessened immeasurably. Luckily, they have a very nice chemistry together. Stone is actually toned down a bit while still retaining the knowing, witty vibe that makes her a sought after actress. Garfield is effective in the quieter scenes, dealing with them the way teenagers often do; even ultra-smart, thoughtful teens pretend to shrug off emotional anguish and try to "play it cool" in moments of vulnerable amity.

Rethinking the Spider-Man Legacy

While most components of the movie work reasonably well, including the supporting actors (Rhys Ifans and Denis Leary are very good as Doc Connors and Captain Stacy), there is a bit of a sputter in the CGI department, particularly regarding the main villain, The Lizard. At times, he's foreboding and bizarre; in some sequences he is clearly animated and smoothly unrealistic. Since Spidey pretty much always looks like a real person in a suit, the lesser CGI Lizard

moments are unfortunately augmented. Still, there are a number of instances in which he appears as an embodiment of evil, with aspects of a horror film peeking through underneath (even the soundtrack is reflective of such junctures).

There's also the issue of the number of people who discover Spider-Man's identity. This is somewhat off-putting at first thought. However, there are the comic stories to fall back on, and pretty much everyone who sees Pete in the costume without the mask also had that knowledge at some point during the "Ultimate" and "Amazing" Spider-Man representations. This is not an excuse, because the unmasking happens so often that it begins to lose it's shock value. Still, it becomes a minor complaint overall, particularly when so much of the Spidey mythos is treated right.

For example, the movie includes what might be Stan Lee's most brilliant cameo, a memorable and laugh out loud moment that can probably

best be described as pure, sheer Marvel. This act looks like a Spider-Man story illustration come to life.

But most importantly, the things that Spider-Man stands for remain intact. The things that he most exemplifies for people of all ages who love and relate to this character so deeply, amplified in light of today's world situation and the children that populate it who are constantly looking for role models, are showcased proudly in this context. The movie has taken quite a bit of heat for a couple of the more "corny" scenes, but those are possibly the points that Spidey fans should be the most pleased with.

Spider-Man isn't about being cynical, after all. His biggest lesson learned is to do the right thing even in the face of personal loss, even when there is seemingly literally nothing to gain for oneself. In this light, the film succeeds at a very high level, with landscapes of gritty reality peppered by the bright ultimate sacrifices of love, injury, and personal suffering. Even the

glory of performing these gestures is lost on a man who appears to the world under the guise of a mask.

The youthful Spider-Man's search for an identity amid a world that finds him absent of most of the people that he's looked up to over the years is a complex, layered one. His closest ally is an older woman not related by blood. He does not fit in among his classmates, aside from a girl who is in constant danger just by way of being his friend. He doesn't even fit in with the older gentleman who reveres the same scientific endeavors as he does.

In spite of that, *The Amazing Spider-Man* is an extension of the comics not just in the absolutely uncanny way in which his web-slinging and iconic poses are recreated cinematically, but also in the code that Spider-Man himself becomes driven to aspire to: the courage to sacrifice one's own happiness if it means preserving the well-being of others.

To act responsibly with his circumstantial moral power, even in the moments when he most does not want to.

The Lords of Salem (2013)

WARNING: MILD SPOILERS

As a reviewer, I generally loathe trashing a film made with an ambition that exceeds the film's outcome. There is a vision in Rob Zombie's *The Lords of Salem* That doesn't quite seem to have made the successful transition from idea to screen, but there's a genuine fascination in the journey that makes giving the movie a closer look worthwhile.

I've often found this to be the case with Zombie's films, especially *House of 1,000 Corpses* and the one I consider to be his most successful (generally in the minority here), his remake of John Carpenter's *Halloween* (theatrical version). There are a few common

threads in all of his movies, and though *The Lords of Salem* has a much different aesthetic in both execution and setup, despite what many critics have written about *Lords* being a departure for Zombie, it (depressingly) doesn't sway too far from what has seemingly become his underlying cinematic agenda: exploring the perceived nihilistic aspect of the human condition.

I find it depressing because outright cinematic nihilism can really only end one way: with nihilism. Seems simple, but the real shame is in the predictability of the inevitable and the lack of any true revelation. There is perhaps another way to view the ending of this movie, depending on your point of view...but more on that later.

On a more positive note, even though the inevitability of his previous films is still strongly on display, the agenda is more well hidden

here. He has managed to hit a few different notes than he's managed before, which is refreshing. For starters, there is a mood achieved and mostly kept throughout the movie that is undeniably creepy, if only mildly so. There is also a presence of subtlety that I have long hoped he would attempt to explore, though the movie never strays too far from the beaten path...while not a lot really happens during the 96 minute run-time, the events are made more unpleasantly memorable by the few intentionally raw, unblinking violent moments contained therein.

First, the good. There are some brilliantly shot scenery segues, with a slightly moving camera and a beautiful score accompaniment that quietly echoes some of the more spooky setups from *The Exorcist*. Though Zombie's writing has constantly been called into question (often with good reason), his skill in achieving imagery shouldn't be. He is, after all, a very successful music video director and a huge fan of classic

horror, both of which come into play during *The Lords*. Almost equally, in fact. And though the urge to toss the words "striking imagery" around exists, in this instance I'd merely call it...*successful* images.

There are a few standout performances, as well, mostly with the group of witches that terrorize radio DJ Heidi (Rob's wife, Sheri Moon Zombie, who is probably once again in way over her head in the huge role). Meg Foster is particularly eerie in a very gutsy part for her. She seems to throw herself headfirst into the character, and winds up having probably the most memorable moments of the film as a result. Veteran Ken Foree is likable as one of the other DJs at the station...but he provides the only truly fun scenes in the film (there aren't many).

There is an intriguing thread weaving its way through the movie, with a group called "The Lords" having sent a record into the radio

station that somehow casts a spell on Heidi and most other females around the mythically tainted town of Salem. For some inexplicable reason, the song, featuring basically three dreary notes played over and over, achieves more than one spin on the radio show. Of course, to this end: it sends quite a few people into an instant tailspin upon hearing it.

Now, though there is a lot to like about *The Lords of Salem*, there are also plenty of strange decisions made throughout the film that can't be swept aside. For one, the climax of the movie...yes, that's a fairly big complaint, I know. Though many reviews have complained that the ending is nothing more than slow paced, bizarrely placed imagery that doesn't lead to anything, I didn't have any problem following what was happening. The problem is bigger than that, unfortunately.

Because the film has kind of a hypnotic oddness to it, I stayed with it, but there is pretty much

zero tension, and that's largely because (SPOILER) one of the movie's three protagonists (arguably the most important, the one used as a storytelling tool to help the audience understand WTF is going on) is killed without much fanfare at the beginning of the third act, and even more inexplicably, the other two have absolutely zero to do with the climax of the film. Even worse, a small, awkward attempt at having any emotional ground to stand on with a love affair between Heidi and the third DJ is basically a MacGuffin; it has no emotional bearing or significance on the outcome and isn't fleshed out well at all.

There is nothing to root for, there is nothing to root against...simply put, there is *no reason to care* about the end of the movie, aside from maybe aimlessly wondering what the inevitable imagery will look like when the plot, heartily and unabashedly borrowed from *Rosemary's Baby*, reaches its potential. Thinking about it a little more, maybe the movie actually has a

happy ending for a few of the participants, but overall the film can really only go in one direction. And yes, it goes there.

The dialogue throughout is often uninspired and unrealistic, partially due to the fact that, quite often, it isn't delivered particularly well. In the case of Sheri Moon's Heidi, I don't know how she could have made some of that stuff successful even if she were a better natural actress. The sad truth is, she's best here at staring off and looking overwhelmed, because, at least in this film, she doesn't cough, laugh or even *smoke* very convincingly. And I'm not nitpicking her; I've defended her heartbreaking part in *Halloween* as far more layered than many figured she could ever pull off, with a deep sadness present behind her eyes in that film, but there isn't really a whole lot of places she could have went with this part that would have cast her in a good light, to be honest. To be fair, she does have a bit of chemistry with the other DJs in the early scenes and quips

along with them on their morning radio show believably. The best I can say overall is, as the main focus of the movie, and given some of the most eye rolling dialogue...she isn't awful.

The reveal of the "creature" near the end of the film (too integral to the plot to say much about here) is even more bizarre...this thing seriously looks like the little monsters in William Castle's *The Tingler* or something that might have been rejected by the producers of the TV show *Fallen Skies*. Some of that scene is saved a bit by the witches themselves, who seem to be having a good old time cackling and generally acting evil. Too bad the movie wasn't more about *them*.

Still, I can't wholly dismiss *The Lords of Salem*. Maybe I have a general fascination with Zombie's films, but there's plenty here to feed that intrigue, whether it be true cinematic prowess or just an obsession.

I wouldn't call myself a big fan (as mentioned before, only two of his films hold any true appeal for me), so I lean more toward the focus of his dark visions. He seems to know what he wants to get out of his movies, even if a large number of the population isn't exactly going along for the ride. I respect that. I like it.

But, as stated before, I really wish he'd examine something different. Though this movie carries some of the more ridiculous aspects of the Halloween sequel (*H2*) image wise, it's still a HUGE step of from that film. I feel like he has a masterful horror film somewhere in that deep, dark, horror fan mind of his that will eventually explode all over the screen, and I'm rooting for him to do it.

The Lords of Salem is not that movie, but it is a strange combination of something new and something very familiar...like Coffin Joe having a fever dream about the silent film *Haxan* if it were directed by Dario Argento.

Yeah, that's weird.

But it carries with it an unshakable, intriguing future promise of more. Just...more.

www.ingramcontent.com/pod-product-compliance
Lightning Source LLC
Chambersburg PA
CBHW070428180526
45158CB00017B/928